BRAIN COMPATIBLE ACTIVITIES

GRADES K-2

DAVID A. SOUSA

Skyhorse Publishing

Visit our website at www.skyhorsepublishing.com.

10 9 8 7 6 5 4 3 2 1

Library of Congress Cataloging-in-Publication Data is available on file.

Cover design by Lisa Riley

Print ISBN: 978-1-63450-362-4
Ebook ISBN: 978-1-5107-0115-1

Printed in China

BRAIN-COMPATIBLE ACTIVITIES

TABLE OF CONTENTS

Connections to Standards

This chart shows the national academic standards that are covered in each chapter.

LANGUAGE ARTS	Standards are covered on pages
Apply a wide range of strategies to comprehend, interpret, evaluate, and appreciate texts. Draw on prior experience, interactions with other readers and writers, knowledge of word meaning and of other texts, word identification strategies, and understanding of textual features (e.g., sound-letter correspondence, sentence structure, context, graphics).	10, 29
Employ a wide range of strategies while writing, and use different writing process elements appropriately to communicate with different audiences for a variety of purposes.	17
Apply knowledge of language structure, language conventions (e.g., spelling and punctuation), media techniques, figurative language, and genre to create, critique, and discuss print and nonprint texts.	20, 26

MATHEMATICS	Standards are covered on pages
Numbers and Operations—Compute fluently, and make reasonable estimates.	39
Algebra—Represent and analyze mathematical situations and structures using algebraic symbols.	36
Geometry—Analyze characteristics and properties of two- and three-dimensional geometric shapes, and develop mathematical arguments about geometric relationships.	33
Measurement—Apply appropriate techniques, tools, and formulas to determine measurements.	42
Data Analysis and Probability—Formulate questions that can be addressed with data, and collect, organize, and display relevant data to answer them.	45

SOCIAL STUDIES	Standards are covered on pages
Understand culture and cultural diversity.	49
Understand the ways human beings view themselves in and over time.	59
Understand individual development and identity.	62
Understand interactions among individuals, groups, and institutions.	56
Understand the ideals, principles, and practices of citizenship in a democratic republic.	53

SCIENCE	Standards are covered on pages
Science as Inquiry—Understand about scientific inquiry.	75
Physical Science—Understand properties of objects and materials.	66
Life Science—Understand characteristics of organisms.	78
Science and Technology—Ability to distinguish between natural objects and objects made by humans.	69
Science and Technology—Identify abilities of technological design.	72

Introduction

Brain-compatible activities are often louder and contain more movement than traditional lessons. Research has shown that purposeful talking and movement encourage retention of new learning. While this may seem out of your comfort zone at first, good classroom management and a willingness to try new things is all that is needed to implement these activities in any classroom. Once you and your students become accustomed to brain-compatible strategies, you will find it difficult to go back to more traditional teaching methods. Students (and teachers!) enjoy lessons that actively involve their brains, and the brains that are actively involved are the brains that learn.

It has been estimated that teachers make over 1,600 decisions per day. As professional educators, it is our job to be familiar with current research to make sure those decisions count for our students. This book is filled with activities that are supported by brain research. These activities will help increase learning because they are structured to maximize the brain's learning potential.

How to Use This Book

The activities in this book are designed using a brain-compatible lesson plan format. There are nine components of the plan, but not all nine are necessary for every lesson. Those components that are most relevant to the learning objective should be emphasized.

1. Anticipatory set
2. Learning objective
3. Purpose
4. Input
5. Modeling
6. Check for understanding
7. Guided practice
8. Closure
9. Independent practice

Each of the components is described in detail in the book titled *How the Brain Learns, Third Edition* (2006). Refer to this book for more brain-compatible research and other teaching strategies.

When using the activities in this book, read through the activity first. Then begin preparations for the lesson. Make sure to follow the lesson plan format to ensure maximum learning potential. However, be flexible enough to meet the needs of all learners in your class. A positive classroom climate is essential for retention.

Put It Into Practice

How the brain learns has been of particular interest to teachers for centuries. Now, in the twenty-first century, there is new hope that our understanding of this remarkable process called teaching and learning will improve dramatically. A major source of that understanding is coming from sophisticated medical instruments that allow scientists to peer inside the living—and learning—brain.

As we examine the clues that this research yields about learning, we recognize its importance to the teaching profession. Every day teachers enter their classrooms with lesson plans, experience, and the hope that what they are about to present will be understood, remembered, and useful to their students. The extent to which this hope is realized depends largely on the knowledge base teachers use in designing those plans and, perhaps more important, on the strategies and techniques they select for instruction. Teachers try to change the human brain every day. The more they know about how it learns, the more successful they will be.

Some of the recent research discoveries about the brain can and should affect teaching and learning. For example, this research has:

- reaffirmed that the human brain continually reorganizes itself on the basis of input. This process, called neuroplasticity, continues throughout our life but is exceptionally rapid in the early years. Thus, the experiences the young brain has in the home and at school help shape the neural circuits that will determine how and what that brain learns in school and later.

- revealed more about how the brain acquires spoken language.

- developed scientifically based computer programs that dramatically help young children with reading problems.

- shown how emotions affect learning, memory, and recall.

- suggested that movement and exercise improve mood, increase brain mass, and enhance cognitive processing.

- tracked the growth and development of the teenage brain to better understand the unpredictability of adolescent behavior.

A much fuller explanation of these discoveries and their implications for school and the classroom can be found in my book, *How the Brain Learns, Third Edition* (2006). This book designed as a practical classroom resource to accompany that text. The activities in this book translate the research and strategies for brain-

compatible teaching and learning into practical, successful classroom activities. They focus on the brain as the organ of thinking and learning, and take the approach that the more teachers know about how the brain learns, the more instructional options they have at hand. Increasing teachers' options during the dynamic process of instruction also increases the likelihood that successful learning will occur.

Some general guidelines provide the framework for these activities:

- Learning engages the entire person (cognitive, affective, and psychomotor domains).

- The human brain seeks patterns in its search for meaning.

- Emotions affect all aspects of learning, retention, and recall.

- Past experience always affects new learning.

- The brain's working memory has limited capacity and processing time.

- Lecture usually results in the lowest degree of retention.

- Rehearsal is essential for retention.

The activities in this book also are backed by research-based rationale for using particular instructional strategies, including cooperative learning groups, differentiated instruction, discussion, movement, manipulatives, metaphors, visualization, and so on, all of which can increase motivation and retention of learned concepts. Those who are familiar with constructivism will recognize many similarities in the ideas presented here. The research is yielding more evidence that knowledge is not only transmitted from the teacher to the learners but is transformed in the learner's mind as a result of cultural and social influences.

The classroom is a laboratory where teaching and learning processes meet and interact. This laboratory is not static but constantly changing as intensive research produces new discoveries about how the brain learns and retains information. The more information educators have, the more they can adjust their understanding and instructional strategies to ensure students are using their brains to the fullest capacity. As we discover more about how the brain learns, we can devise strategies that can make the teaching-learning process more efficient, effective, and enjoyable.

Language Arts

The human brain is not hardwired for reading. Our brains can master spoken language quickly. However, because the act of reading is not a survival skill, the brain requires explicit training in reading. Learning to read requires three neural systems and the development of skills that work together to help the brain decode abstract symbols into meaningful language. The visual processing system sees the printed word; the auditory processing system sounds out the word; and the frontal lobe integrates the information to produce meaning. It is a bidirectional and parallel process that requires phonemes be processed at the same time. Reading is testament to the brain's remarkable ability to sift through input and establish meaningful patterns and systems.

Reading is one of the most difficult skills for the brain to master, and under current legislation, students must master it at earlier ages than ever. It is crucial, therefore, that you choose activities that capture students' attention and promote retention. While the following activities are content-specific, they can be easily modified to fit your curriculum.

As the brain is developing skills to decode the meaning of sounds and symbols, it is creating semantic and syntactic networks that aid in communication. Verbal and written communication involves syntax and semantics to create meaning. The syntactic network uses the rules of language, or grammar. The semantic network combines the components of language and the mind's search for meaning. The brain holds two separate stores for semantics, one for verbally based information and another for image-based information. Using concrete images to teach abstract concepts will greatly increase retention. The brain builds on speaking skills to develop and refine all language abilities—speaking, reading, writing, and grammar.

> "There are no areas of the brain that specialize in reading. Reading is probably the most difficult task we ask the young brain to undertake."

Blending Bowl

Standard

Apply a wide range of strategies to comprehend, interpret, evaluate, and appreciate texts. Draw on prior experience, interactions with other readers and writers, knowledge of word meaning and of other texts, word identification strategies, and understanding of textual features (e.g., sound-letter correspondence, sentence structure, context, graphics).

Objective

Students will orally blend phonemes to form words.

Anticipatory Set

Gather ingredients to make brownies (find a recipe in a kid-friendly cookbook or online). Place the individual ingredients on a table so all students can see. Have the students name each ingredient as you place it in a large mixing bowl. While mixing the ingredients together, ask students to think about what might happen to the ingredients. Invite students to share their thoughts with a partner. Then show them the batter that resulted from blending of the individual ingredients.

Purpose

Remind students that they have been learning the individual sounds associated with letters of the alphabet. Tell them they are going to see what happens when these individual sounds mix together to form something new. *Like the ingredients blended together to form the brownie batter, letter sounds can also blend together. When letters blend together they form words. Today you are going to practice blending letter sounds together to form words.*

Input

Tell students that words are made up of individual sounds. Show them how they can figure out the individual sounds of a word by looking at each letter in the word. The letter sounds blend together to form the word. Tell students that reading is just mixing the letter sounds together!

Modeling

Before the activity, reproduce the **Alphabet reproducibles (pages 12–15)** on cardstock. Cut out the word and letter cards. Hide the word cards in the bottom of a bowl. In front of the class, place the letter cards *c, a,* and *t* individually in the bowl. Have students identify the sound of each letter as you drop it into the bowl. Stir the letters with a spoon and pull out the card with the word *cat.* Blend the sounds together orally for students, and have them repeat the blending after you. Repeat the activity with different letter cards and the resulting words.

Alphabet Page 12

Check for Understanding

Place more letters in the bowl; stir them together; pull out the letters; and write them on a card. Ask students to look at the card and blend the letters together silently in their heads. Have students share the blended word with their partners and encourage them to praise one another for correct responses. Repeat several times, and observe each student pair to assess understanding.

Guided Practice

Before guided practice, reproduce the Alphabet reproducibles used earlier, and ask a volunteer to cut out the letters. Give each pair of students a small bowl and a set of individual letter cards. Have students place the letter cards in the bowl and stir them with a spoon. Give students a copy of the **Blending Bowl Word List reproducible (page 16)**. Have students pull out the letters that correspond to the first word and practice blending the letter sounds to form the word. Students should draw a bowl under the word to remind them to blend the sounds of the letters. Replace letters, and repeat until each word has been blended.

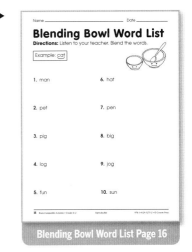

Blending Bowl Word List Page 16

Closure

Give each student a cooked brownie to eat. Ask students to think about the different ingredients that were used to make the brownies and how they blended together. *How is blending the brownies similar to blending letter sounds to read words? Think about your answer for ten seconds.* Invite volunteers to share their thoughts with the class.

Independent Practice

Have students take the Blending Bowl Word List reproducible home and read the words to a parent by blending the sounds.

Alphabet

A	B	C
D	E	F
G	H	I

Alphabet (cont.)

J	K	L
M	N	O
P	Q	R
S	T	U

Alphabet (cont.)

V	W	X
Y	Z	
cat	map	van
leg	ten	set

Alphabet (cont.)

zip	win	dig
nod	fog	pot
hug	rug	bun

Blending Bowl Word List

Directions: Listen to your teacher. Blend the words.

Example: cat

1. man

2. pet

3. pig

4. log

5. fun

6. hat

7. pen

8. big

9. jog

10. sun

You'll Never Guess . . .

Standard
Employ a wide range of strategies while writing, and use different writing process elements appropriately to communicate with different audiences for a variety of purposes.

Objective
Students will demonstrate creative thinking and narrative writing skills.

Anticipatory Set
Read aloud the first line of the story on the **You'll Never Guess reproducible (page 19)** to students. Ask them to silently invent the next line of the story. Wait several seconds. Invite students to give oral responses. Laugh with students about humorous and creative ideas.

Purpose
Tell students that they are going to continue this creative thinking as they work with a group to write several narratives.

Input
Spend a few minutes instructing students about narratives. Remind them that narratives tell a story and can be real or made-up. Be sure to use words appropriate for your students' ability levels.

Give each student a copy of the You'll Never Guess reproducible, and have students write the definition of a narrative in their own words at the top of the page. Encourage students to share their definitions with group members. Then instruct groups to write fictitious narratives about something that could happen on their way to school.

Modeling
Divide the class into groups. Model the process with one group first. Students catch on to the process very quickly when they see it done, but it is difficult to explain. Using the reproducible, allow the first student one minute to complete the first sentence of the story. After one minute, call *Time*, and have the student pass the paper to the classmate on the right. Allow time for the new student to read the first sentence, and then give him or her one minute to write a sentence to sensibly follow the first. Repeat until papers are returned to the original owner. The end result is a story begun by one student but added to and completed by the other members of the group.

▶

You'll Never Guess... Page 19

> **The use of imagination and a positive classroom climate have been found to increase student retention rates.**

Guided Practice

Have groups complete their stories. Play background music (no lyrics) with approximately 60 beats per minute to promote creativity and to help control noise.

Closure

Invite volunteers to read their stories aloud. Encourage and praise students for their creativity.

Independent Practice

As appropriate, instruct students to write their own fictitious narrative for homework.

Name _____ Date _____

You'll Never Guess...

- -

A narrative is _____

Directions: Finish the story.

You'll never guess what happened on the way to school today. The day was perfectly normal until…

- -

- -

- -

- -

SCHOOL BUS

Flashcard Hop

Standard
Apply knowledge of language structure, language conventions, media techniques, figurative language, and genre to create, critique, and discuss print and nonprint texts.

Objective
Students will identify middle and ending sounds in words and use these sounds to locate rhyming words.

Anticipatory Set
Read the class a book or poem with rhyming words, such as *Fox in Socks* by Dr. Seuss. Ask students what makes the book unique compared with other books they have read. Allow time for students to think, and then request oral responses.

Purpose
Remind students that words with similar middle and ending sounds are called *rhyming words*. Tell them that they will be finding rhyming words in a flashcard game.

Input
Before playing the game, help students identify rhyming words in a passage. Using the book from the anticipatory set, read a page aloud and ask students to identify the rhyming words on that page. If possible, point to the words as you say them or write them on cards for a pocket chart. Have all students repeat the rhyming words after you. Continue until students grasp the concept of middle and ending sound similarity.

Modeling
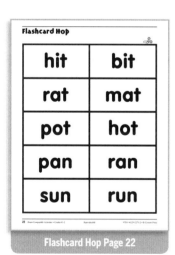

Flashcard Hop Page 22

◀ Before the activity, copy the **Flashcard Hop reproducibles (pages 22–25)** onto cardstock. Cut apart the cards, and laminate them for durability. To play the game, give each student a flashcard. Using your own flashcard, sound out your word and show it to students. *Someone in the room has a flashcard that rhymes with mine. When the music plays, I am going to try to find the person with that flashcard.* Model how students should hold their flashcards for others to read while walking around trying to locate a word that rhymes with their own. When you locate the student with a rhyming flashcard, give him or her a high five, and sit down with

your rhyming partner. Tell students that they will play the game just like you did. The game will begin when the music starts.

Guided Practice

Start the music (no lyrics), and prompt students to locate their rhyming partner. When all students have found their partner and are seated, have them read aloud their rhyming word pairs. After all students have shared, ask them to trade cards with a different classmate and repeat the game. Play the game as many times as necessary to reinforce the concept.

Closure

Ask students to write or dictate in their journal as many of the rhyming words as they can remember from the game.

Independent Practice

For homework, ask students to find ten rhyming words in a book, magazine, or newspaper. Have them write down the words or ask an adult to help them.

> The use of games brings novelty and movement into the classroom. Both are needed for the brain to focus.

Flashcard Hop

hit	bit
rat	mat
pot	hot
pan	ran
sun	run

pin	fin
get	pen
den	pet
dig	pig
duck	luck

blue	clue
seat	heat
hair	fair
dime	time
lake	rake

dear	fear
rock	sock
flower	tower
bank	tank
skip	ship

Segmenting Blues

Standard

Apply knowledge of language structure, language conventions, media techniques, figurative language, and genre to create, critique, and discuss print and nonprint texts.

Objective

Students will demonstrate phonemic awareness by segmenting words into syllables.

Anticipatory Set

Play jazz music. Encourage students to clap along with the beat. Ask them to identify some of the instruments they hear in the music. Lower the volume of the music and talk to students about jazz. Describe the unique qualities of jazz music, and point out the interesting beats and rhythms. Then discuss some of the instruments musicians use to sustain the beat of the music, such as a drum or a bass. Display a picture of a bass. Focus on the bass, and point out the picture.

Purpose

Remind students that words can be divided into sounds or segments, just as music is divided into beats. Word segments are called *syllables*. Tell students they are going to make their own instruments to help them hear the syllables in words.

Input

Remind students that we hear the syllables in words by listening for the different sounds within the word. Demonstrate by saying aloud several words, emphasizing each syllable. Ask students to clap out the syllables and count the sounds as you say the word. Practice with short words such as *cool, sing,* or *music*. Then progress to words with more syllables such as *piano, tambourine,* or *musician*. Repeat each word several times, emphasizing the syllables.

Modeling

Cut a piece of yarn about one yard in length. Place one end securely under your foot and wrap the other end around one of your fingers. Pull the yarn tight, so when it is plucked with the other hand it makes a sound. Tell students this is your "bass" and you will use it to help count the syllables in words. Ask students to suggest words and model how to

count the syllables by plucking the yarn once for each syllable.

Check for Understanding

Give each student a long piece of yarn and ask them to pluck out the syllables as you say the words. Continue to model how to pluck the bass while emphasizing the syllables. Visually assess students to see if they are counting syllables with you.

Guided Practice

Once students seem to master the technique, ask them to pluck out and count the syllables of words with a partner. First, call out the words orally. Student pairs listen carefully to the word, pluck out the syllables together, agree on the number of syllables, and then hold up fingers indicating that number. Praise students who show the correct number, and assist those who are incorrect.

Closure

Play the jazz music again, and allow students to pluck their instruments to the music. Ask them to think about how the beats of the music are like the syllables in words. Invite them to discuss their thoughts with a partner.

Independent Practice

Give students a copy of the **Segmenting Blues reproducible (page 28)** to complete for homework. They should have someone at home read the words aloud. Students can clap or use their instruments to determine the number of syllables in each word and then write the number of syllables on the line.

> **Kinesthetic learners need to involve their bodies in order to learn.**

Segmenting Blues Page 28

Name _____ Date _____

Segmenting Blues

Directions: Have a grown-up read these words aloud. Clap or use your string instrument to count the number of syllables. Write the number on the line next to each word.

1. Jazz _____

2. Horn _____

3. Guitar _____

4. Trumpet _____

5. Singer _____

6. Harmonica _____

7. Saxophone _____

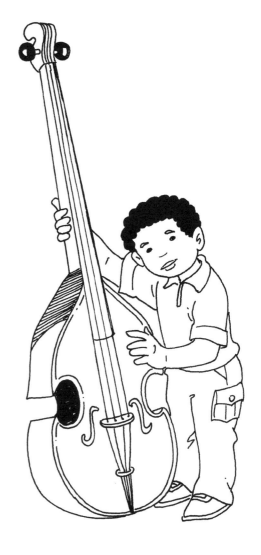

Fluency in Motion

Standard

Apply a wide range of strategies to comprehend, interpret, evaluate, and appreciate texts. Draw on prior experience, interactions with other readers and writers, knowledge of word meaning and of other texts, word identification strategies, and understanding of textual features (e.g., sound-letter correspondence, sentence structure, context, graphics).

Objective

Students will use a kinesthetic signal to improve reading fluency.

Anticipatory Set

Show students a picture or a model of a traffic light. Ask students what each of the lights signifies to drivers (*red = stop, green = go, yellow = slow down*).

Purpose

Talk to students about what a yellow light means for drivers (slow down). Tell students there is a sign in reading that signals the reader to slow down or pause for a moment. Tell them they are going to learn what that sign is called, what it looks like on paper, and what movement will signal them to pause when reading.

Input

Show students a comma on the board or overhead, and remind them that it is called a comma. *This punctuation mark is called a comma. It signals to readers that they need to pause briefly before continuing.* Demonstrate how a comma is similar to a smile. Develop a hand signal that will remind students to pause for a comma while reading (for example, a finger pointing to the corner of your mouth). Show students the signal, and tell them you will use it to remind them when to pause. Students can also use it to remind themselves or others to pause during reading.

Modeling

Write sentences containing commas on sentence strips, and put them in a pocket chart. As you read the first sentence aloud, pause briefly and demonstrate the comma signal when you encounter a comma. Ask students to show you the signal. Then read the other sentences while pointing to each word. When you encounter a comma, check to see that

> **Kinesthetic symbols add a multisensory component to lessons, which can increase retention.**

all students are showing the comma signal. Finally, have students repeat the sentences after you. Emphasize fluency.

Check for Understanding

Continue modeling until all students can indicate the correct locations of commas using their signals.

Guided Practice

Pausing for Commas Page 31

◄ Give students a copy of the **Pausing for Commas reproducible (page 31)**. Divide the class in half, and have students form two lines facing one another. Assign one line to be the readers and the other line to be the listeners. When you indicate, readers read aloud the first sentence. Listeners will help the readers remember to pause for commas by using the comma signal. At your command, ask readers to slide to the right so they can read the next sentence to a new partner. Continue in the same manner for five sentences. Instruct students to change roles. The readers become listeners, and the listeners become readers. Repeat the activity as described above. Remind students to praise and encourage their classmates. All readers need to feel secure when reading aloud.

Closure

To close the activity, have students do-si-do through the lines until you say *Stop*. Ask them to tell the person they are facing what a comma indicates, and show them the comma signal.

Independent Practice

For homework, ask students to read aloud the sentences on the reproducible to a grown-up. Remind them to read fluently.

Pausing for Commas

Directions: Read the following sentences. Use the hand signal as a reminder to pause at each comma.

1. I saw Pat, Min, and Don at the park.

2. "I saw you," said Don.

3. The dog ran away, and the cat went up the tree.

4. The blue bat is too big, but the red bat is too small.

5. Do you have the ball, the bat, and the hat?

6. Helen has a sandwich, but I have a cupcake.

7. "Be careful on the swings," said Mom.

8. I like to climb trees, and you like to play hopscotch.

9. Charles is a big man, and he can run fast.

10. Maria can run, hit, and catch the ball.

Mathematics

> **You cannot recall information that your brain does not retain.**

Mathematics is often the least favorite subject for both students and teachers. A common misconception about math is that facts and figures cannot be fun, so lecture is often the primary strategy used to impart this wisdom on the next generation. Lecture, however, has been proven the least effective method for long-term retention. It is no wonder students develop a disdain for math. It is hard to like something you struggle to retain.

The following activities are proof that mathematics objectives can be taught in brain-compatible ways and can actually be (dare we say it?) fun! Since math concepts on paper are abstract, one of the easiest ways to make them more brain-compatible is to use concrete strategies, such as movement and manipulatives.

A math journal is a great way to help students reflect on the concepts taught during math instruction. Taking time to reflect on new learning or applying new concepts to promote higher-order thinking can enhance retention of material and be accomplished effectively in a journal.

Geometry Lingo

Standard
Geometry—Analyze characteristics and properties of two- and three-dimensional geometric shapes, and develop mathematical arguments about geometric relationships.

Objective
Students will identify geometric shapes using correct terminology.

Anticipatory Set
Gain class attention by greeting students using incorrect names. Ask students to think about how it felt to be called by the wrong name, and encourage volunteers to share with the class. Pose questions that help students brainstorm the possible problems or confusion caused by using the wrong name for a person or object. Allow adequate wait time, and solicit oral responses.

Purpose
Tell students they are going to learn about the importance of using correct terminology in mathematics. They are going to practice identifying geometric shapes by their mathematical names.

Input
Before the activity, locate pictures or manipulatives of various geometric shapes. Hold up the shapes while you say the correct name of each one. It is important to use the correct terminology when introducing the shapes. Therefore, it is best not to let students guess the names of the shapes at this point. Have students repeat the names of the shapes after you. If this is the first time they have been exposed to geometric shapes, emphasize the differences between a square, a rectangle, and other rhombuses you may be covering.

Check for Understanding
Show the shape pictures again, one by one. Give students think time after each picture, and then have them consult with a partner about the correct name of the shape. Call on students to give the correct name.

> During the initial phase of a lesson, it is crucial that students hear only correct information.

Modeling

Tell students they are going to play a game to help them identify geometric shapes. Students will use the correct math terminology to identify shapes around the classroom. Model the game by displaying the **Geometry Lingo reproducible (page 35)** on the board or on an overhead projector. Pretend to search the classroom and find a piece of paper on your desk. Think aloud about the shape you found. *Here is a rectangle. It has four angles and two pairs of equal sides. I am going to draw a picture of this piece of paper next to the word* **rectangle** *on my paper.* Demonstrate how you want students to complete the reproducible. Instruct them to work with a partner to find other examples of geometric shapes in the classroom.

Geometry Lingo Page 35

Guided Practice

Give students a copy of the Geometry Lingo reproducible. Help them read the names of each shape on the page. When students are comfortable with the terminology, have them work with a partner to find geometric shapes represented in objects around the classroom. Instruct them to draw the objects next to the correct geometric names listed on the reproducible. Play background music (no lyrics) during the activity to encourage focus and retention. While students are searching, assess their progress and redirect as needed. After students have found all of the shapes, invite pairs to share the objects they found with the class. Praise them for using correct terminology.

Closure

Have students return to their seats. Show them the shape pictures again and ask them to quietly recall the name of the shape. Repeat the process, this time asking students to say the name of the shape as you show it. Close the activity by having students list as many shape names as possible in one minute in their math journals. If students do not write, encourage them to draw the shapes instead.

Name _____ Date _____

Geometry Lingo

- -

Partner: _____

Directions: Draw a picture of an object in the room with the same shape.

Circle	(circle)	
Square	(square)	
Rectangle	(rectangle)	
Oval	(oval)	
Triangle	(triangle)	

Fun Facts

Standard
Algebra—Represent and analyze mathematical situations and structures using algebraic symbols.

Objective
Students will show whole number computation using manpulatives.

Anticipatory Set
Ask three students from one side of the room to stand up, and then ask two students from the other side of the room to stand. Challenge the class to tell how many students are standing all together. *(five)* Have those students sit down. Ask four different students from one side of the room to stand and one student from the other side of the room to stand. Challenge the class to tell how many students are standing all together. *(five)* Think aloud and wonder how both groups can equal five. *We just made five in two different ways. We used people to show that three plus two equals five and that four plus one also equals five. I wonder how many different ways we can find to represent whole numbers.*

> Having students apply new learning increases the level of thinking involved.

Purpose
Tell students they are going to work with a group to find different ways to show numbers.

Input
Remind students that putting numbers together is adding. Instruct them about addition facts using age-appropriate terms. *The different ways we can put numbers together to form a bigger number are the addition facts for that number.*

Modeling
Model how to find some more examples of number facts. Challenge students to help you find two different ways to show six. Place two pens and four pencils together on a table. Demonstrate how two pens and four pencils make six writing utensils. Think aloud while you demonstrate. *I have two pens and four pencils. That means I have six writing utensils.* Model a second example. Place five crayons and one pair of scissors on the table. Pose questions that encourage students to tell how many objects are on the table. *How many crayons do I have? How many scissors do I have? How many art supplies do I have all*

together? Help students understand that there are different addition facts that equal six. Inform students that they are going to find different ways to represent numbers. When you say a number, they will work in groups to find objects in the room that form that number when added together.

Check for Understanding

Make sure that students understand they are trying to find different objects to represent the addition facts, not simply the given number. For example, do not show six pencils to represent six but rather three cups and three blocks.

Guided Practice

Organize students into learning groups of three or four. Randomly call out numbers from two through ten (or higher, if age appropriate). Give groups time to locate and place objects to represent the addition facts. Ask a spokesperson from each group to share the group's addition fact. Write each fact on the board. Go over the facts for each number before moving on to a new number.

Closure

Ask students to reflect on the following question: *What patterns do you see in the addition facts of whole numbers as the numbers get larger?* (Larger numbers have more facts. You can use patterns to help you identify all the facts, such as starting with 1 + ___ = ___; 2 + ___ = ___, etc.) Beginners can give oral responses. More advanced students can write in their math journals.

Independent Practice

Give students a copy of the **Adding with Pictures reproducible (page 38)** to complete individually. Explain that they will be drawing pictures of the objects representing the addition fact instead of simply showing the objects. This step will help bridge the gap between the concrete objects and the abstract numbers used to represent the facts.

Adding wtih Pictures Page 38

Adding with Pictures

Directions: Draw pictures of objects to complete the addition facts.

Example: [crayons] + [brushes] = 5

1. [] + [] = 2

2. [] + [] = 4

3. [] + [] = 7

4. [] + [] = 8

Money Counts

Standard
Numbers and Operations—Compute fluently, and make reasonable estimates.

Objective
Students will use money to develop whole-number computation skills.

Anticipatory Set
Show students a picture of a popsicle. Ask a student to tell you what the object is. Then ask the class if they like popsicles. Continue questioning to get students to tell where they might buy a popsicle (a store) and how they would pay for it (with money). Think aloud about buying a popsicle for a treat. *I sure would love to buy a popsicle like this one, but it costs 65 cents.* Show a handful of coins. *I have these coins, but I need some help counting out the right amount. Will you help me?* Count out the correct amount, asking students to help decide the next coin needed.

Purpose
Tell students that counting money may seem difficult but that it is just another form of addition. Then tell them they are going to practice computing numbers with a money counting game.

Input
Before playing the game, assess students' level of understanding about coins. Show quarters, dimes, nickels, and pennies (or pictures of coins), and tell the number each coin represents. Write the amounts on the board so students can visualize the coin corresponding to a number. Encourage students to touch the coins and discuss the differences in size, color, and value.

Modeling
Show students how to figure out the amount of money they have when putting different coins together. Use visuals (manipulatives, pictures of coins, or real coins) to demonstrate how to add the number amounts. For example, two dimes and four pennies can be written $10 + 10 + 1 + 1 + 1 = 24$. When we add those amounts together we learn that two dimes and four pennies equals 24 cents. Think aloud and practice with different coin combinations.

> Including tactile, visual, and auditory components in a lesson increases the chances of retention for a greater number of students.

Check for Understanding

Challenge students to practice several problems before playing the game. Place two quarters and two nickels where students can see them. Ask students to tell how much money is shown. Give them a chance to work the problem and then write their answers on individual white boards or pieces of paper. Have students show you their answers simultaneously to check for understanding. Repeat with different amounts as needed.

Guided Practice

◄ Enlarge and photocopy the **Money Counts reproducible (page 41)** onto cardstock. Make enough copies so that each child in the class has a coin. Attach a piece of yarn to the enlarged coins so students can wear them around their necks. Give each student one coin necklace.

Then tell them you will say an amount of money and write it on the board. On your signal, students will mingle around the room to form groups whose coins add together to equal the amount written on the board. Each student in the first group to form the correct amount earns one point. Repeat the exercise to compute other amounts. Provide a reward for the three students with the most points. If the competitive nature of this game causes stress instead of fun with your students, play the game without the points component.

Money Counts Page 41

Closure

Close the lesson by taking out a box of popsicles or pencils. Tell students they can "buy" one from you by drawing coins on a piece of paper that add up to 72 cents. Let students enjoy the popsicles or pencils they earn. Instruct students to think about the Money Counts game. Prompt them to respond to the following question in their math journals: *If the amount you just drew can buy one popsicle, what coins would be needed to buy two popsicles?*

Money Counts

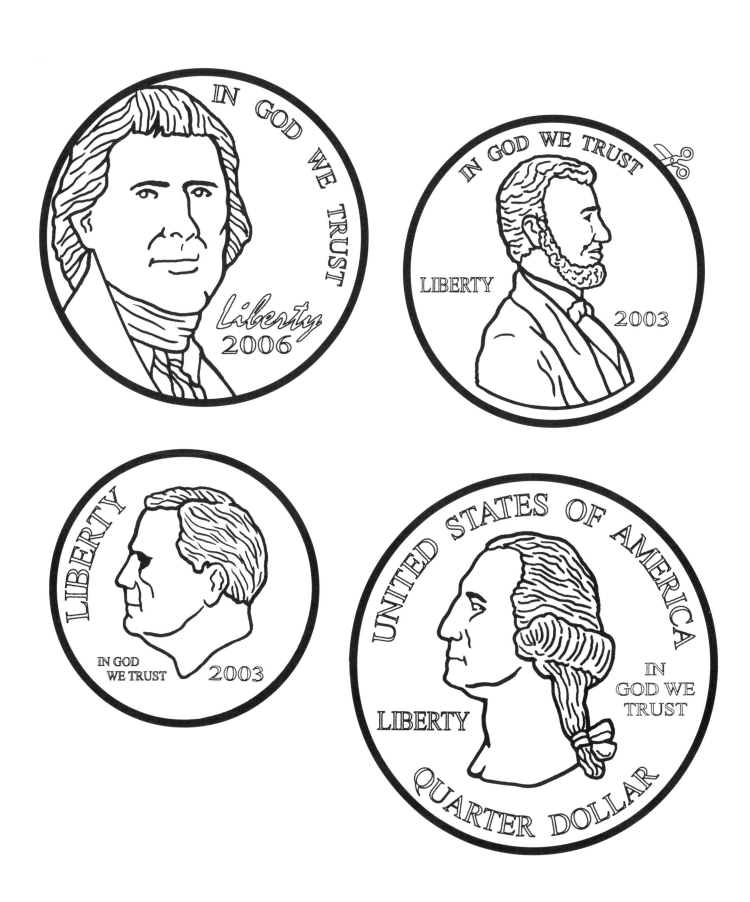

Measurement Relay

Standard
Measurement—Apply appropriate techniques, tools, and formulas to determine measurements.

Objective
Students will apply techniques and tools to measure liquids.

Anticipatory Set
Show students measuring cups and half-gallon and gallon milk jugs. Ask them to identify the objects and think about how they are similar. Continue to ask questions to get students to understand that we can use containers to measure liquids. Each of the containers measures a different amount.

Purpose
Tell students they are going to learn the names of some of the units used to measure liquids. Tell them they are going to work with a team to discover how many small units (the cup) are needed to fill the larger unit (the gallon).

Input
Discuss measurement with students. *Liquids can be measured with several different tools. The tools that we are going to be learning about today are a cup, a half-gallon, and a gallon.* Show each measurement tool as you discuss it. Tell students they will need to discover how many of the smaller units are needed to fill the larger ones.

Guided Practice
Divide students into teams of four. Have each team select one person record the data. Tell students they are going to be in a relay race to determine how many cups of water are needed to fill a gallon jug. Prior to the activity, ask a volunteer to fill a bucket of water for each team. Place the buckets at the starting line and the gallon jugs at the finish line. Place a measuring cup next to each bucket. At the start of the race, the first student in each team will fill the cup with water from the bucket, walk briskly to the gallon jug, empty the water into the jug, return to the starting line, and pass the cup to the next student. Remind students to try not to spill any water! Repeat the procedure until the gallon jug is full. The recorder keeps a tally of the number of cups needed to fill the gallon jug for each team. The winner is the team that fills its jug first

> Discovery lessons can be a novel alternative to direct instruction.

and can report the correct number of cups needed to fill a gallon *(16)*. This activity works best outside. It is also wise to have a fill-line marked on the gallon jug to reduce controversy over how full the gallon jug must be to win. Have all teams complete the activity, even if another team has already won.

Modeling

Return to the classroom, and instruct the teams to count the tally marks and write the number on the **Measuring Liquids reproducible (page 44)**. Make sure students write down the number *16* next to the gallon jug on their reproducible if they have not done so already.

Measuring Liquids Page 44

Next, encourage students to extend their thinking about measurement and discover a different way to find other measurements for liquid. *You did a great job of discovering how many cups are in a gallon. You found out that there are 16 cups in a gallon. Now, I want you to put on your thinking caps. If there are 16 cups in a gallon, how many cups would you guess there would be in a half-gallon?* Allow time for students to think. Have students discuss their thoughts with a partner. Then prompt them to write one option in their math journals. Ask volunteers to share their problem-solving technique but not the answer.

Choose one of the techniques suggested by students, and demonstrate it on the board or overhead. Show students how they can figure out that half of 16 cups is eight cups. Therefore, a half-gallon contains eight cups. Draw pictures to help reinforce the concept and model the independent practice.

Closure

Have students answer the following questions in their math journals.

1. Milk comes in gallon and half-gallon containers. If I drink all of the milk from the gallon jug, how many cups of milk will I drink?

2. If I drink all of the milk from two gallons, how many cups will I drink then? Do you think I would have a stomach ache?

Independent Practice

Encourage students to complete the Measuring Liquids reproducible by drawing pictures that show how many cups are in a gallon and a half-gallon. Allow students to use images that are meaningful to them.

Name _____ Date _____

Measuring Liquids

Directions: Write the number of cups needed to fill each container. Draw pictures to show how many cups are in a gallon and a half-gallon. Draw pictures that will help you remember what you learned today.

Gallon = _____ cups 	Half-gallon = _____ cups

Graphing Similes

Standard
Data Analysis and Probability—Formulate questions that can be addressed with data, and collect, organize, and display relevant data to answer them.

Objective
Students will create and interpret a bar graph.

Anticipatory Set
Read to students a version of Hans Christian Anderson's *The Princess and the Pea.* Start a discussion about how high the bed really was. Use a simile to describe the height of the bed. *The bed was as high as* _____. Allow students to "popcorn" responses that would complete the statement. (Examples: *a tree, the school, my dad,* etc.)

Purpose
Remind students of the definition of a simile. Ask them to repeat the word after you so they can hear and feel the correct pronunciation. During the discussion of similes, emphasize the use of imagination in comparing unlike objects. Tell students they will be using their imaginations to create similes and creating a special graph that will show how the similes are alike.

Input
Give each student a sticky note. Instruct them to complete the simile at your prompt. They can write or draw their response. *The bed was as high as* _____. Allow several seconds for students to think about their answer; then ask them to write or draw the response on the sticky note.

Tell students they will create a bar graph of the responses. If necessary, remind students what a bar graph looks like and what information it gives. Make the connection between the similes on the sticky notes to the class bar graph you will create. *Now, I would like to see how similar your responses are. We are going to create a bar graph that will show us how many people made a comparison to things closest in size to a person, a house, or a mountain. A bar graph will show us quickly how many of you came up with similar comparisons.*

> Imagining adds novelty and meaning, which can increase retention.

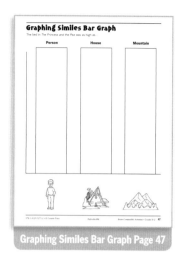

Graphing Similes Bar Graph Page 47

Modeling

◄ Enlarge a copy of the **Graphing Similes Bar Graph reproducible (page 47)** to poster size. Place the poster in the front of the room. Point out the labels on the graph, and discuss the meaning of each. Instruct students to look at their sticky notes to determine where to place them on the graph. *Look at your sticky note. Is your response closest in size to a person, a house, or a mountain?* Model how to complete the task. Tell the class the simile you wrote, and then place your sticky note in the appropriate column. Think aloud while you model the task. *I wrote* **school** *on my sticky note because I thought the bed was as high as the school. A school is closest in size to a house, so I will put my note in the column under the house.*

Check for Understanding

Assess understanding using oral questioning. Repeat instructions as needed.

Guided Practice

Call on students individually to share their responses and place their sticky notes on the bar graph. Help make sure they place their notes in the correct columns. Students must estimate and compare their responses to the graph headings. This may be difficult for some students. Coach as needed.

Closure

After all students have placed their sticky notes on the bar graph, explain how the graph visually displays the data. Lead a discussion to analyze the data. *How many students thought the bed was closest in size to a human? To a house? To a mountain? Did more of you come up with responses which were closer in size to a human, a house, or a mountain?* Allow time for students to look at the graph. Ask them to write their responses in their math journals.

Graphing Similes Bar Graph

The bed in *The Princess and the Pea* was as high as...

Person	House	Mountain

Social Studies

Learning and retention are different. We can learn something for just a few minutes then lose it forever.

Social studies objectives lend themselves to brain-compatible teaching strategies. However, it is difficult for teachers to determine the main concepts on which to focus. Social studies texts, while a helpful resource, are filled with minute details which may not be vital to a child's understanding of the main ideas. If we want students to retain the information long-term, we have to be aware of how short- and long-term memory work. The brain of a young child can process only about five chunks of new information at a time. Therefore, if we want students to remember what we teach them, we have to limit the amount of material we cover and find ways to help them better retain what we do cover. The idea is to do a better job of teaching less.

Students can learn facts and information and hold the memory long enough to take a test. Retaining the information requires the learner to give conscious attention to facts and build conceptual frameworks to move the information into long-term memory. In social studies, students are often required to memorize important dates, names of people, and significant places. Rote rehearsal helps students remember facts for tests. Elaborative rehearsal, in which students reprocess the information numerous times, requires students to discover relationships, make associations with prior learning, and interpret meaning. Elaborative rehearsal will help students remember those important dates, people, and places for much longer than next week's test.

Concept maps and visualization are a great way to help students make sense of new learning in social studies. Brain-compatible social studies instruction is as much fun for teachers as it is for students. Just remember, less is more!

Home Sweet Home

Standard

Understand culture and cultural diversity.

Objective

Students will utilize a concept map to organize facts about houses in different regions of the world.

Anticipatory Set

Ask students to think about the place they live or different types of houses they see in the community. Invite them to share their thoughts with the class.

Purpose

Tell students they are going to learn about houses in different parts of the world and how they are similar to or different from the houses in their community.

Input

Briefly talk about how all humans need food, water, and shelter. Explain that people all over the world have the same needs but meet their needs in different ways. Tell students they will learn more about different types of houses in different parts of the world.

Modeling

Place a transparency of the **Home Sweet Home reproducible (page 51)** on the overhead projector. Prepare a transparency of the **I Know/I Wonder reproducible (page 52)**, and keep it handy. Model for students how they will read the passage and ask themselves questions as they read. *As I read each sentence, I am going to use the I Know/I Wonder chart to write down facts I already know and questions I have about what I read.* Read aloud the first sentence on the reproducible. Then think aloud about what you know and what you wonder. *When I read this, I already know that people live in different kinds of houses, so I am going to write that in the **I Know** column on my worksheet. I wonder what kind of houses people live in where it is really cold. I am going to write that in the*

> Recalling personal experience will help students attach meaning to the new material.

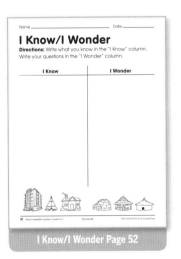

I Know/I Wonder Page 52

I Wonder column on my worksheet. Instruct students to do the same thing as they read the passage. When they finish, students will have a T-chart containing facts from the passage and questions to research.

Guided Practice

Provide each student with a copy of the Home Sweet Home and I Know/ I Wonder reproducibles. Divide the class into pairs, and direct them to find an area of the room where they can read aloud and discuss their questions. Allow adequate time for students to read the passage, write notes, and discuss questions.

Check for Understanding

Circulate among the pairs as they read to ensure they comprehend what they are reading. Ask questions to assess comprehension and prompt critical thinking.

Closure

When pairs are finished reading, have students return to their seats. Invite volunteers to read facts from their *I Know* columns and list them on the board. Add any facts from the passage that were not addressed by students. Ask students to quietly consider why houses are different in different places. After allowing time to think, remind students that houses are different depending on the environment. The environment determines the materials available to build houses and the amount of shelter needed.

Independent Practice

Prompt students to circle one question from the *I Wonder* column on their T-chart. Challenge them to find the answer to their question. Students may use the Internet or other resources. Consider taking them to the school library for research time.

Name _____ Date _____

Home Sweet Home

The world has many houses. Some houses are square and tall. Some houses are round and small. Houses can be close together. Houses can be far apart. Some houses float on water. Some houses are built on mountains. Houses are made for the weather. Houses are made of wood, mud, stone, or straw. A stone house will last a long time. A house without walls will let in the cool air. A house with thick bricks will be warm inside. Houses are all different.

Name _____ Date _____

I Know/I Wonder

Directions: Write what you know in the **I Know** column.
Write your questions in the **I Wonder** column.

I Know	I Wonder

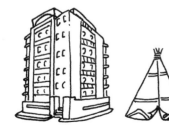 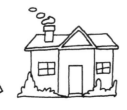 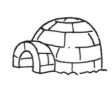 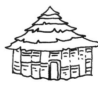

Visualizing Democracy

Standard
Understand the ideals, principles, and practices of citizenship in a democratic republic.

Objective
Students will use visualization to enhance retention of vocabulary words.

Anticipatory Set
Tell students they are going to vote on whether they want to sit in their seats or on the floor for this lesson. Take a vote by a show of hands, and allow students to sit in the spot determined by the majority.

Purpose
Tell students they are going to learn about the form of government we have in our country and some of the words associated with it.

Input
Lead a discussion about the democratic form of government we have in the United States. Remember to keep the language on an age-appropriate level. Make sure to use and define the terms *democracy, vote,* and *equality.* Ask students to use the words when they are speaking and asking questions during the discussion.

Modeling
Tell students that pictures and a word web help to show how words relate to one another. Put a transparency of the **Democracy Word Web reproducible (page 55)** on the overhead projector. Demonstrate how to complete the word web using pictures. Read the definitions and think aloud while you draw a picture as an example. *To help me remember what each word means, I am going to use the definition and my imagination to draw pictures that represent each word. The pictures need to be something that makes sense to me. For example, in the* **vote** *box, I am going to draw our class voting on where to sit for this lesson. The picture will help me remember that* **vote** *means to choose something.* Draw a sketch in the box containing the word *vote.*

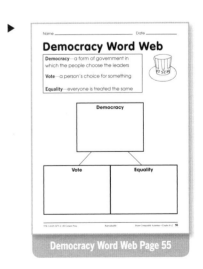

Democracy Word Web Page 55

> Talking stimulates the frontal lobe of the brain, where thinking starts.

Check for Understanding

Check for understanding using a quick assessment technique such as "thumbs up" for *yes* and "thumbs down" for *no*. Explain again as necessary.

Guided Practice

Have students draw pictures in each of the three boxes on the word web. Encourage them to think of their own ideas for each word. Assist with word meanings as needed.

Closure

When students have completed their word webs, have them share their work with a partner. Ask students to share how their pictures remind them of each vocabulary word and how the words are related to one another. Invite volunteers to share with the entire class.

Democracy Word Web

Democracy—a form of government in which the people choose the leaders

Vote—a person's choice for something

Equality—everyone is treated the same

Democracy

Vote	Equality

Relationship Hoops

Standard
Understand interactions among individuals, groups, and institutions.

Objective
Students will demonstrate an understanding of the role of people in institutions such as schools.

Anticipatory Set
Tell students some corny, age-appropriate jokes related to school. *What do you call a donkey in a classroom?* (school mule) *What do you call a hammer in a classroom?* (school tool) *What do you call a classroom in the middle of a pond?* (pool school) *What do you call an arm wrestling match between two teachers?* (school duel)

> Humor adds novelty and helps students focus.

Purpose
Tell students they are going to play a game to learn about institutions such as schools and how people in communities interact with them.

Input
Lead a discussion about institutions. Talk about how institutions are organizations or groups made up of people who serve a purpose in the community. Examples of institutions include schools, religious communities, and hospitals. Institutions are important because they serve many different purposes in a community. Schools, for example, serve the purpose of educating young people so they will grow up to be smart, hard-working citizens. Just like institutions have important roles in communities, people have important roles in institutions.

Modeling
Instruct students to form a big circle in the room. Ask everyone to join hands and imagine that the circle represents the school. The school is an institution made up of people. You will ask each student to name a person or role in the school, such as *the secretary*, *teacher*, *student*, or *librarian*. Model what you want students to do by naming an individual who is an important part of the school. Then show students how to pass a hula-hoop around the circle without letting go of one other's hands.

Guided Practice

Ask each student to name a person who helps make schools run smoothly. Start the hula-hoop around the circle by stepping through and passing it to the person on your right without dropping hands. Continue until the hoop has gone all the way around the circle.

Closure

Have students return to their seats. Prompt them to think about the activity you just completed. Guide a discussion about how everyone had to work together to get the hula-hoop around the circle. Emphasize that people in institutions have to work together to accomplish the goals of the institution. Everyone and every job is important. Give students a copy of the **People and Institutions reproducible (page 58)**. Demonstrate how to complete it. Instruct students to think about an institution other than a school (hospital, religious community, library, scouting group). Ask students to write the name of the institution on the line at the top of the page. Then have them write some of the names of people who might work in that institution in each link of the chain. Finally, have students form small groups to share their work.

▶

People and Institutions Page 58

People and Institutions

Directions: Think of an institution in your community. Write the name of the institution on the line. Write names of people in the institution in each link of the chain.

Institution: _____

Did You See That?

Standard
Understand the ways human beings view themselves in and over time.

Objective
Students will construct a timeline.

Anticipatory Set
Ask a colleague to dress in funny attire that would be memorable to students, such as large clown sunglasses, a feather boa, and cowboy boots. Arrange for the colleague to run into your classroom just as you start the lesson. Leave several items in plain view of the students (e.g., purse, coffee cup, trophy). The bandit will quickly "steal" the items and then dash from the room.

> Novelty helps the brain focus.

Purpose
Tell students they will need to help you describe what happened to the police. Tell them they will construct a timeline to show what happened in order.

Input
Talk about the importance of trying to remember events in a logical order. Tell students that a timeline is one way to organize events in sequence. *A timeline is a type of map that shows what happened first, then second, then third, and so on.* Show students an example of a timeline and demonstrate how it is read from left to right, like a sentence. Tell students they are going to create a timeline of the "crime" they just witnessed.

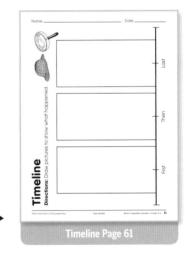

Timeline Page 61

Modeling
Put a transparency of the **Timeline reproducible (page 61)** on the overhead projector. Ask students to try to recall everything that happened when the suspect entered the room. Encourage them to consider the physical description of the suspect and the events that followed. Allow time to think. Point to the first box on the timeline. Show where to draw a picture of the first thing that happened. The next thing that happened goes in the middle box, and the last thing that happened goes in the box on the right. Show students where to draw their pictures, and make sure they understand what to do. However, do not draw a picture as an example because you want students to recall the events.

Check for Understanding

Give students a copy of the Timeline reproducible. Have them place their fingers on the box where they will draw what happened first, second, and last. Visually assess student understanding.

Guided Practice

Allow students to use pencils and crayons to complete the reproducible. Assist as needed without giving hints regarding the events. When students finish, have them share their timelines with a partner.

Closure

Post the timelines on a bulletin board. Ask students if there were differences between their timelines. Initiate a discussion about how people remember events differently, even when they see the same event. *Our timelines show that we all paid attention to different aspects of the crime and thought different things were important.* Help students to realize the same thing often happens in the world today. People view events and situations in diverse ways. It does not mean someone is wrong if they view something differently; it just means their perspective is different.

Independent Practice

What might happen when people remember things differently? Ask students to write or draw the answer in their journals.

Name _____ Date _____

Timeline

Directions: Draw pictures to show what happened.

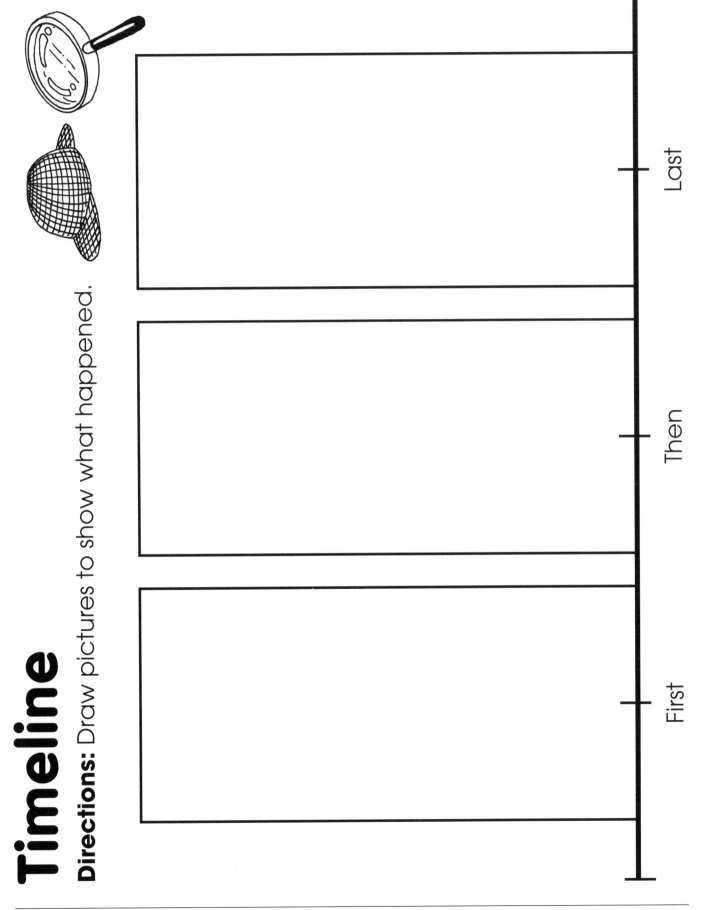

Last

Then

First

Families on Target

> The brain is most focused early in a lesson. It is important to provide correct information.

Standard

Understand individual development and identity.

Objective

Students will create a family map to show their nuclear and extended families.

Anticipatory Set

Show students pictures of your family and talk about how they are related to you.

Purpose

Tell students they are going to talk about families and learn about nuclear and extended families.

Input

Begin a discussion about families. Talk about the uniqueness of families and what makes a family. Point out the differences between nuclear families (those closest to you) and extended families (aunts, uncles, grandparents, etc.). Be sure to use age-appropriate language, but use correct terminology when referring to nuclear and extended families. It is important to be sensitive to various family situations during this activity.

Modeling

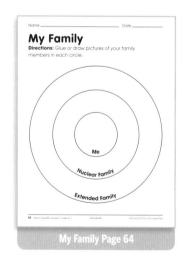

My Family Page 64

◄ Prepare a poster-sized copy of the **My Family reproducible (page 64)**. Demonstrate for students how to complete it. *I am going to show you the pictures of my family again, but this time I am going to use this circle map to help you see who is in my nuclear family and who is in my extended family.*

Think aloud as you place the pictures on the map. Show a picture of yourself, and paste it in the middle circle. *I am going to place my picture in the center of the map because this map is about my family.* Show pictures of your nuclear family, and paste them in the middle circle on the map. *I am going to place the pictures of my mom, dad, and siblings in the middle ring of the circle map. This ring represents my nuclear family, as they are the closest to me.* Show pictures of your extended family, and paste them in the outer circle of the map. *In the outer ring I am going to put pictures of my grandparents, aunts, uncles, and cousins. They are my extended family.*

Guided Practice

Give each student a copy of the My Family reproducible. Take a digital picture of each student, and print it out in a small size (can be done prior to the activity). Have students glue their pictures in the center of their circle maps. Then have them draw pictures of their nuclear family in the middle ring of the map. Pictures of extended family members will go in the outer ring. Play music (no lyrics) with 60 beats per minute to encourage creativity and productivity. As an alternative, have student bring photos of family members from home.

Check for Understanding

Circulate around the classroom to ensure students are completing the map correctly. You may need to assist some students to identify their nuclear and extended families. Be sensitive to all family relationships.

Closure

Allow students to share their family circle maps with the class. Emphasize that all families are unique and that there is no right or wrong kind of family. Different families are part of what makes each person special. Close the activity by encouraging students to dance to the song "We Are Family."

Independent Practice

Ask students to write or draw in their journals about things they like about their families.

Name _____ Date _____

My Family

Directions: Glue or draw pictures of your family members in each circle.

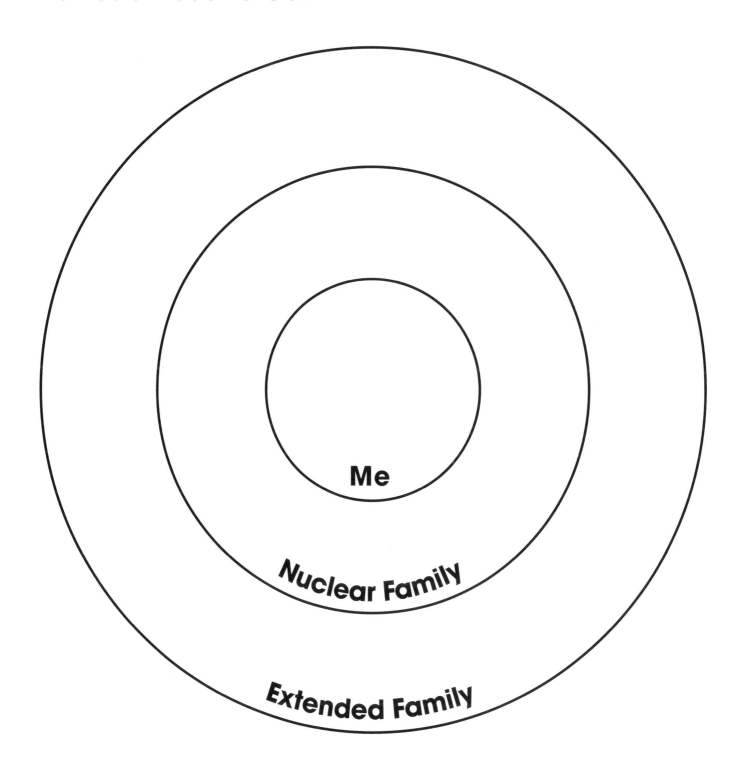

Science

The scientific technology of the last two decades has allowed teachers to know more about how students learn than any of our predecessors knew. With this information comes excitement and challenge. It is up to us to use this new knowledge to foster a love of learning in the next generation. In the field of science, this is especially true.

For a brain to store information in long-term storage areas for future recall, the learning must make sense and have meaning. Brain scans have shown that when new learning is readily comprehensible (sense) and can be connected to the past experiences (meaning), there is substantially more cerebral activity, followed by dramatically improved retention. (Maquire, Frith, & Morris, 1999)

Making meaning has a tremendous impact on whether or not information will be stored. In order for students to retain the concepts they are learning, they must make a connection with their own experience. If that experience is a positive one, it is more likely the students will continue to actively participate in learning. If the experience is negative, the students will likely turn off to the learning and store very little information.

Science curriculum can be viewed by students as relevant and filled with discovery, or it can be viewed as mundane memorization. The way in which we teach it makes the difference.

> **People will participate in learning activities that have yielded success for them and avoid those that have produced failure.**

Pasta Challenge

Standard

Physical Science—Understand properties of objects and materials.

Objective

Students will organize pasta into a classification system that makes sense.

Anticipatory Set

Walk to the center of the room carrying a large bowl of dry pasta of various shapes, colors, and sizes. Pretend to trip, and spill the pasta onto the floor. Tell students you will need their help to get the pasta back in order.

Purpose

Tell students that scientists take facts and observations and come up with ways to organize them in a manner that makes sense. Explain that they will work in groups to come up with a way to organize the pasta in a logical way.

Input

Talk about classification. Tell students that classifying objects means to sort them in a way that makes sense. Scientists classify things to keep them organized. Objects can be classified by smell, shape, taste, color, or almost any characteristic!

Modeling

Pick up pieces of pasta off the floor. As you do so, think aloud about how you will classify the objects. *If I were going to organize this pasta, I could do it several ways. I could look at its shape and put it in groups of pasta with the same shape. I could also classify it by color and put it in groups of pasta of the same color. I might also look at size or weight.* While you are talking, hold up several pieces of pasta to demonstrate your system. Demonstrate how to glue the pasta onto poster board using the classification system you developed. Then explain to the class how you classified the pasta. *I put all of the curved ones together. I put all of the squiggly ones together.*

> Young students enjoy being helpful. This is a great way to add humor and novelty to gain student focus.

Check for Understanding

Ask students to show you a "thumbs up" if they understand what to do or "thumbs down" if they do not understand. Explain again in a different way until everyone understands the task.

Guided Practice

Divide the class into a small groups. Instruct group members to pick up pieces of pasta from the floor and come up with a way to classify them. Allow groups to choose their own system of organization as long as it makes sense and is consistent. Remind students they will need to be able to tell the class how the pasta in each group is the same. When the pasta is organized, have students glue the pasta to a piece of sturdy poster board to show their classification system. A timer and background music (no lyrics) can enhance productivity. Walk among groups as they work, and assist as needed. At the end of the designated time, have each group stand and share their classification system.

Closure

Have students return to their seats and complete the Group Work reproducible, if appropriate. As an alternative, use the reproducible to lead an oral class discussion to reflect on learning.

Name _____ Date _____

Group Work

Directions: Finish the sentences.

The people in my group were _____

We did a great job of _____

We could have done better by _____

I learned _____

Natural or Human-Made

Standard
Science and Technology—Ability to distinguish between natural objects and objects made by humans.

Objective
Students will complete a T-chart to list natural and human-made objects.

Anticipatory Set
Dress as Mother Nature with a flowing robe, leaves in your hair, and a stick wand. Pretend to be Mother Nature throughout the lesson. Talk to students about who Mother Nature is and what objects are natural.
I am Mother Nature. My job is to keep track of all the natural objects on earth, but my job is getting harder and harder. Humans are making so many objects now that I often get confused trying to determine which objects are natural and which objects are made by people. I have been trying to check on the natural objects around your school, but I need your help. Will you help me?

Purpose
Tell students they are going to help find objects from the school grounds and determine whether they are natural or made by humans.

Input
Give a short lesson on the difference between natural objects (rocks, plants, water, animals) and human-made objects (rubber, plastic, paper, metal). Use age-appropriate language but correct terminology. Provide some real-life examples of both types of things, and encourage students to think of other items that fit in each category. Be sure to allow plenty of think time.

Modeling
Make a transparency of the **Natural or Human-Made reproducible (page 71)**. Give ▶ each student a copy of the reproducible, and place a transparency on the overhead projector. Demonstrate how to complete the chart using examples of natural and human-made objects. Then explain to students that they will go outside the classroom to look for examples of objects that are natural or human-made. When they find an object that is human-made, they will write its name or draw a picture of it in the

> Using an example familiar to students will help provide meaning for the new learning and increase retention.

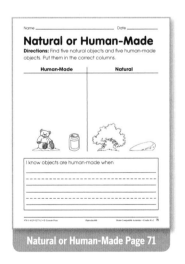
Natural or Human-Made Page 71

Human-Made column. Natural objects will go in the other column. Instruct students to find five examples of each kind.

Check for Understanding

Check for understanding by questioning students about various objects in the classroom. *Is the coffee mug a natural or human-made object?* Then ask in which column the item should be listed. *Since this is a human-made object, I will write it in the* **Human-Made** *column.*

Guided Practice

Take students outside. Make sure they have a copy of the reproducible and a pencil or crayon. Set a time limit and boundaries. Encourage students to ask one another for help before asking you. Wander around, and assist as needed. Prompt students with questions, and help them decide where to place the objects on the chart. At the end of the time, use a signal to gather students back to the classroom.

Closure

Have students return to their seats upon entering the classroom. Ask them to review their T-charts and then answer the question at the bottom of the page. For nonreaders, read the question aloud, and ask students to talk with a partner about their answer.

Independent Practice

For homework, have students draw pictures of three human-made objects and three natural objects they find in their homes.

Natural or Human-Made

Directions: Find five natural objects and five human-made objects. Put them in the correct columns.

Human-Made	**Natural**

I know objects are human-made when _____

Turn On to Technology

Standard

Science and Technology—Identify the abilities of technological design.

Objective

Students will generate ideas to solve a problem using new technology.

Anticipatory Set

Place a bucket of water, a rock, and a stained article of clothing on a table in one corner of the classroom. In another corner of the room, place bread, peanut butter, and jelly on a table. (Due to the prevalence of peanut allergies, you may use butter and jelly.) Divide the class into two groups. Send one group to the washing center and the other group to the sandwich center. Instruct students to try to get the stain out of the clothing using only what is on the table. Tell the other students to make a peanut butter (or butter) and jelly sandwich using only what is on the table.

Allow about ten minutes for students to work. Use a signal to gather students back to their seats. Guide a discussion about how these two tasks could be done easier. Invite volunteers to talk about what they did to wash the clothing or make the sandwich. Ask students to talk about what people use to make tasks easier (e.g., *machines, utensils, tools*).

Purpose

Tell students they are going to learn the word *technology* and see how technology makes our lives easier.

Input

Give a brief lecture about technology. Be sure to use age-appropriate language, but use correct terminology. *Technology is something created by humans to accomplish a task. Technology makes our lives easier. For example, a washing machine is technology that helps people wash clothes much faster than water and a rock. Knives and spoons are technology that help people prepare and eat food in easier ways.* Talk about how people use their imaginations to design new technology to solve a problem.

Modeling

Model for students how to use your imagination to solve a problem. Start by identifying the problem. Show a sock with a hole in it. *I have a problem right here. I wish I could think of ways to avoid holes in my*

Using the example from the anticipatory set will help provide meaning to the new learning.

socks. After identifying the problem, think aloud about many different ways to solve the problem. *I could invent a fabric that never tears. I could invent a hole detector.* Tell students that there are no wrong ideas when using one's imagination. Talk about how technology is created. People take an idea and figure out a way to make it work. That process may take a long time, but eventually someone will have a new invention.

Guided Practice

Lead a class in brainstorming about common problems in a primary grade classroom. For example: *Markers run out of ink; paint dries up; craft sticks need to be stored; papers need to be distributed.* Write students' responses on the board.

Divide the class into small groups, and give each group a copy of the **Turn On to Technology reproducible (page 74)**. Tell students that a light bulb ▶ can be used as a symbol for a new idea. Point to the light bulb on the page. Instruct students to think about one of the problems listed while brainstorming. Have them write down all the ways they could solve the problem. Remind students to use their imaginations and respect everyone's ideas. There are no wrong answers.

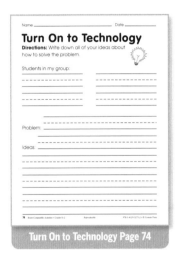

Turn On to Technology Page 74

Closure

Allow students to share their ideas with the class. Encourage them to praise one another. After everyone has had a chance to share, ask students to turn to their neighbors and tell them the definition of *technology* and how it makes our lives easier.

Turn On to Technology

Directions: Write down all of your ideas about how to solve the problem.

Students in my group:

_____ _____
- - - - - - - - - - - - - - - - - - - - - - - - - - - - - -
_____ _____
_____ _____
- - - - - - - - - - - - - - - - - - - - - - - - - - - - - -
_____ _____

Problem: _____

Ideas: _____

What's in the Jar?

Standard
Science as Inquiry—Understand about scientific inquiry.

Objective
Students will use their five senses to investigate the contents of a jar.

Anticipatory Set
Prior to the lesson, fill a jar with dark chocolate syrup, and cover it with plain paper. Place the jar in a noticeable location in the classroom. Refuse to answer questions about the jar or even acknowledge its existence. Once interest in the jar has reached its peak, walk over to it and casually say: *I wonder what could be in this jar. It looks like we have a mystery to solve!*

Purpose
Tell students they are going to become scientists to solve the mystery of what is in the jar.

Input
Talk to students about how scientists find answers. Discuss how scientists use their five senses to do tests and experiments to test their hypotheses. Define the term *hypothesis* for students, and ask them to repeat the word after you. Discuss the steps necessary to test a hypothesis. As you talk about the steps, mention the five senses, and have students identify each body part as you talk about that sense. Keep the language as simple as possible, but make sure the concepts are clear.

Modeling
Give students a copy of the **Lab Sheet reproducible (page 77)**. Discuss how scientists keep track of everything they do on lab sheets or computers. Prompt students to think of a hypothesis for what might be in the jar. Allow time to think. Encourage students to write their hypothesis on the top line of the lab sheet. Before students test their hypothesis, demonstrate the correct procedures. Show them how to use a clean wooden stick to taste. Remind them to dip only once! Show them how to gently move the substance around in the jar to listen to the sound (avoid spills). Provide wet wipes for after touching the chocolate. Then show students how to record their findings on the lab sheet with detailed descriptions.

Lab Sheet Page 77

Guided Practice

Invite students to test their hypotheses. Have them use their senses to determine how the contents of the jar looks, smells, feels, sounds, and tastes and record their findings on the lab sheet. (Note: Tell students they should never taste something that they are unsure about. For this inquiry, it is safe because you prepared the substance.) For large classes, make multiple jars filled with chocolate syrup. Set the jar in a place where students can observe, touch, smell, taste, and listen. Remove the paper wrapping. Remind students to write down their results on the lab sheet.

Closure

Have students return to their seats and complete the last question on the lab sheet. Reveal the contents of the jar. Invite volunteers to share their hypotheses and how they discovered and identified the substance.

Independent Practice

For homework, have students make a list of mysteries or things they wonder about. How could they become scientists to solve the mystery?

Name _____ Date _____

Lab Sheet

Directions: Use your five senses to test your
hypothesis.

My hypothesis: I think the jar contains _____

Does my hypothesis still make sense? _____

Whales and Sharks

Standard
Life Science—Understand characteristics of organisms.

Objective
Students will compare and contrast whales and sharks using a Venn diagram.

Anticipatory Set
Show students a picture of a shark. Ask them to think about how they would feel if they saw one in the ocean. Invite volunteers to share their feelings with a facial expression. Show a picture of a beluga whale. Ask students to think about how they would feel if they saw one in the ocean. Invite volunteers to share their feelings with a facial expression. Explain that both animals live in the ocean but that they are very different.

Purpose
Tell students they are going to compare the characteristics of whales and sharks to see how they are alike and how they are different.

Input
◄ Give students a copy of the **Whales and Sharks reproducible (page 80)**. Read the passage to students, or have students read in pairs. Help them organize the facts using a Venn diagram constructed from hula-hoops. Try using the hula-hoop for its intended purpose. When you can't keep it going any longer, make a joke about using it for the lesson. Tape one hula-hoop on the board. Think aloud as you place it on the board and label it *Whales Only*. Tape a second hula-hoop on the board, slightly overlapping the first hoop. Think aloud as you label it *Sharks Only*. Label the overlapping section *Both*. Show students how to use the diagram to compare and contrast whales and sharks.

Modeling
Think aloud to show students how to complete the activity. After reading the passage, think aloud about a fact you remember. Write the fact on a sticky note. *I remember the paragraph said that whales are mammals. I am going to write **mammals** on this sticky note.* Ask students to help you figure out where to place the sticky note on the diagram. *Now, where would I put this on our chart? Point to the circle where I would put this*

The positive solicitation of emotions can enhance student retention.

Whales and Sharks Page 80

information about whales. That's right. It will go here in the **Whales Only** *circle.* Tell students they will help you complete the diagram.

Check for Understanding

Use a quick assessment technique to check for understanding. Try "thumbs up" or "thumbs down," *yes* or *no* cards, or red light and green light signs.

Guided Practice

Give each student a sticky note. Encourage students to refer back to the passage. Call on students at random, and ask them to tell you a fact. Help them summarize their statements into short phrases and write them on the sticky notes. Because it takes young students a few minutes to write even simple words or phrases, have several of them working at one time. Nonwriters may draw a picture to represent a fact. Prompt students to place their sticky notes in the correct part of the diagram. Coach as needed. When all of the sticky notes have been placed, read aloud the sections of the diagram to students.

Closure

Lead a brief discussion about how the hula-hoop diagram makes it easier to keep track of the similarities and differences between whales and sharks. Call it a *Venn diagram,* and make the connection between the hula-hoop diagram and one on paper. Give students the **Whales and Sharks Diagram reproducible (page 81)**, and have them copy the facts from the large diagram onto their paper.

Independent Practice

Have students find three more facts about whales and sharks to add to their Venn diagram for homework.

> **The process of moving from concrete to abstract paper diagrams helps students better comprehend the concept map.**

Whales and Sharks Diagram Page 81

Whales and Sharks

Whales and sharks are both animals that live in the ocean, but they are different in many ways.

Whales are mammals. They must have air to breathe. Whales can stay under the water for a long time. They must come to the surface to get air. Sharks are fish. They have gills instead of lungs. Sharks need water to breathe. Sharks must keep moving for water to pass over their gills.

Whales are warm-blooded animals. Sharks are cold-blooded. Shark bones are made of cartilage so sharks will be light and fast. Whale bones are heavier to support the weight of these large animals.

Whales and sharks have a few things in common. Both whales and sharks have live babies. There are also many different species of both whales and sharks. Finally, people fish for whales and sharks to use their skins, meat, and oils.

Whales and Sharks Diagram

Sharks Only

Both

Whales Only

Physical Education and The Arts

> We have never discovered a culture on this planet—past or present—that doesn't have music, art, and dance.

Observe any preschool classroom, and you will see students singing, dancing, and drawing. These activities enhance learning for young children. Cognitive areas of the brain are developing as children finger paint, sing songs, chant rhymes, and dance. The cognitive benefits of these activities continue throughout childhood and into young adulthood, yet art and music classes are the first to be eliminated during school budget cuts.

Music

Listening to music provides therapeutic benefits; however, there are educational benefits as well. Research studies have shown a strong correlation between music and achievement in mathematics. Music and math share several concepts: patterns, geometry, counting, ratios, proportions, equivalent fractions, and sequences. Therefore, developing the cognitive areas of the brain with music can enhance the skills needed for mathematical tasks.

Visual Arts

Imagery is visualization in the mind's eye of something a person has actually experienced. The more information an image contains, the richer and more vibrant it becomes. Students can be taught to use imagery to enhance learning and increase retention. Teachers should integrate imagery as a regular classroom strategy across the curriculum.

Movement

The more scientists study the cerebellum, the more we realize that movement and learning are inescapably linked. Physical movement increases blood flow and brings oxygen to the brain. Higher levels of oxygen in the blood significantly enhance cognitive performance. Dance, specifically, helps students become more aware of their physical presence, spatial relationships, breathing, timing, and rhythm. Engaging other cerebral aptitudes enhances integration of sensory perception.

Color Changes Everything

Objective

Students will demonstrate knowledge of the color wheel and the impact colors have on human emotions.

Anticipatory Set

Hold up a piece of red poster board. Ask students to share with a neighbor what they think about when they see this color. Hold up a piece of green poster board. Ask students to share with a neighbor what they think about when they see this color. Repeat the process with yellow and blue poster board.

Purpose

Tell students they are going to learn about cool and warm colors and how those colors can change the way a piece of art makes you feel.

Input

Talk to students about how artists use colors. Display examples of various pieces of art, and help students identify the colors the artist used. Explain that artists carefully choose the colors they use in their paintings based on how they want the painting to make people feel.

Prepare the **Color Wheel (page 85)** according to the directions. Mount it on cardstock for durability. Show students the color wheel. Point to each color on the spectrum as you identify it by name. Point out the cool colors and the warm colors. Tell students that cool colors are usually calming and warm colors make people feel energetic.

Modeling

Reproduce the **Color Cards (page 86)** on cardstock. Copy enough so each student will have one card. Cut out and shuffle the cards. Make a transparency of **The Circus reproducible (page 87)**. Demonstrate how students will complete the task. Show how to select a color card and color the picture using only that color. Students may use different shades of the color, but it must be the same color. For example, they may use light blue and dark blue. Use crayons or pastels for this assignment.

A pair-share strategy fosters the active engagement of a higher percentage of students. The active brain is the brain that learns.

The Circus Page 87

Check for Understanding

Check for understanding by using a quick assessment technique. Try "thumbs up" or "thumbs down", happy face or straight face, or another hand signal.

Guided Practice

Allow students to draw a color card, and help them read the word if necessary. Give each student a copy of The Circus reproducible. Have students color the picture of the circus using only the color shown on the card. Assist as needed. Play background music (no lyrics) with 60 beats per minute to enhance creativity.

Closure

As students finish, mat their pictures on construction paper, and mount them on the wall. Have students sit where they can see all the pictures together. Lead a discussion about how the colors affect the picture. How do the pictures make students feel? Have students either reflect in a journal or discuss with a partner.

Color Wheel

Use this outline to create a color wheel to demonstrate warm and cool colors for the Color Changes Everything activity.

Color the circle in the 12:00 position red. Color the circle in the 2:00 position orange. Color the circle in the 4:00 position yellow. Color the circle in the 6:00 position green. Color the circle in the 8:00 position blue, and color the circle in the 10:00 position purple.

Color Cards

Red	Red	Red	Orange
Orange	Orange	Yellow	Yellow
Yellow	Green	Green	Green
Blue	Blue	Blue	Purple
Purple	Purple		

Name _____ Date _____

The Circus

Directions: Color the picture using only the color on your color card.

What's in a Name?

Objective
Students will create and sing a song using their names to tell about themselves.

Anticipatory Set
Play or sing the song "John Jacob Jingleheimer Schmidt." Encourage students to sing along.

Purpose
Tell students they are going to create a song about themselves using their own names.

Input
Ask students to think about other songs they know that use a person's name. Some examples include "Mary Had a Little Lamb," "B-I-N-G-O," "John Brown's Baby," and "Little Miss Muffet." Tell students that each of these songs gives a clue about the person. Mary had a lamb as a pet. Little Miss Muffet was afraid of spiders. Talk to students about how a song can be used to express thoughts and emotions.

Modeling
Model on the board how to brainstorm about oneself. Think aloud as you write down things you like, things you do for fun, or other things that make you special. If students are nonwriters, you can use pictures to record your ideas.

Once you have recorded all of your ideas, choose one or two ideas, and create a short song about yourself. You can use the tune from a popular children's song or develop your own tune. Sing your song for the class.

Check for Understanding
Use a quick assessment technique to check for understanding. Try "thumbs up" or "thumbs down," happy or straight face, or *yes* or *no* cards.

Guided Practice
Encourage students to brainstorm about themselves on a separate piece of paper. They can use pictures or words to record their ideas. Assist

students as needed.

After they have recorded their thoughts, ask students to create a short song about themselves. They can use some of the ideas they recorded on their paper. Prompt them to use a familiar tune or create a new one.

Invite volunteers to sing their song to the class. Or go on a tour of the main office to entertain the staff! Remind students to respect everyone's creativity.

Closure

Guide a discussion about what the class learned about each other. Pose questions to students to encourage them to remember what other students sang about.

We've Got the Beat

Objective

Students will be able to recall and create rhythm patterns.

Anticipatory Set

Play a lively piece of music and clap off-beat. Ask students to identify what is wrong. Guide the discussion so students understand that you are not clapping with the beat, or rhythm, of the music.

Purpose

Tell students they are going to recognize the beat in different pieces of music and play a memory game to practice rhythm patterns.

Input

Talk to students about the beat, or rhythm, of music. The beat determines the pace or tempo of the song. Teach students to listen to music to try to identify the rhythm.

Modeling

Play different pieces of music, and clap the correct rhythm of the song. Have students repeat the beat after you model the rhythm for each song. Once students are proficient at this, extend the activity by turning off the music and just clapping a rhythm.

When students seem comfortable with the task of clapping a rhythm, tell them you will establish a pattern and they will copy it. Demonstrate a sample, such as three quick claps and two foot stomps. Show students how they will repeat the pattern after you.

To make this a game, introduce the element of competition. If a student does not correctly repeat the pattern, he or she must sit down. Model how to do this by intentionally messing up the pattern and sitting down. The winner of the game is the last person standing. If your class does not respond well to competition, complete the activity without asking students to sit down if they are incorrect. You do not want to jeopardize a positive classroom climate.

Check for Understanding

Check for understanding using a quick assessment technique, or have students explain the task to a partner.

Guided Practice

Give students a simple rhythm pattern at first. The patterns should get progressively harder. Use different parts of your body, such as one hand clap, two foot stomps, one thigh slap, one mouth pop. Play until you have a winner. If time permits, invite a volunteer to be the leader and create new patterns.

Closure

Repeat the song you played in the anticipatory set, and have students clap the beat correctly with you. Ask students to think about what they learned about rhythm and share their thoughts with a partner. Invite volunteers to share with the class.

Acting Out in Reading

Objective
Students will use drama to comprehend and recall stories in the reading curriculum.

Anticipatory Set
Show a brief clip from a video of a fairy tale.

Purpose
Tell students they are going to learn about drama and how it can help them remember a story.

Input
Talk to students about drama and how it helps people remember a story. Use age-appropriate language but correct terminology. *The video we just watched is based on a book. Sometimes watching a story being acted out by people or cartoon characters helps us to remember it. The acting out of a story is called* **drama**. *We are going to use drama to help us remember the story we are working on in reading.*

Read aloud the story that students are currently working on in the reading curriculum. Help students understand that they have to figure out the plot and the characters before they can act out the story. Define *characters* (people or animals) and *plot* (action), and invite volunteers to help you give examples. Tell students they are going to work with a learning group to determine the characters and plot of the story so they can act it out for the class.

Modeling
Demonstrate how to prepare for the drama by showing a transparency of the **Planning Our Drama reproducible (page 94)**. Explain that people plan stories for movies or plays using a storyboard. Student will use thier own storyboard to show the plot, or sequence of events, in the story. This will help them act out the story for classmates. At the top of the page, show students how to write the title of the story and the characters' names. Use an example from the story you read earlier.

Then show students how to draw the most important events from the story in the boxes in order. Point out the numbers *1–6*. Explain that they will choose the six most important events from the story to draw in their storyboard. Model for students by thinking aloud as you choose the first

Planning Our Drama Page 94

> Purposeful use of media can add novelty to a lesson, which can increase focus.

important event from the story and draw a simple sketch in the first box. Finally, explain how students should assign roles for the drama and practice acting out the story.

Check for Understanding

Make sure all students understand the requirements for the activity. Repeat the steps as needed.

Guided Practice

Divide the class into groups. The size of the group will be influenced by the number of characters in the story. Give students a copy of the Planning Our Drama reproducible, and ask them to gather with their group. Circulate among the groups to ensure they are completing the reproducible and working together to develop a drama. At the end of the designated time, have groups present their dramas to the class. Encourage students to praise one another for their efforts. If appropriate, present the dramas to other classes or on Parents' Night.

Closure

Ask students to turn to a partner and tell the story in their own words.

Name _____ Date _____

Planning Our Drama

Directions: Write the names of the characters. Draw or write the events of the story in the boxes.

Story Title: _____

Characters: _____

1	**2** →	**3**
4	**5** →	**6**

Teamwork

Objective
Students will learn to work with a team to keep a ball in play without going outside the boundaries.

Anticipatory Set
Take students outside or to the gymnasium. Give each student a small rubber ball and ask him or her to bounce it as many times as possible without losing it. Tell students they are not allowed to move their feet.

Purpose
Tell students they are going to learn about the importance of working with a team.

Input
Discuss with students how teamwork can make a job easier or better. Pose questions to students about teams they know or are involved with, such as soccer teams, baseball teams, or professional teams. Get them talking about how teammates work together to win games.

Modeling
Draw a four-foot square on the ground with chalk or masking tape to create boundaries. Start bouncing the rubber ball. Try to keep it in play as long as possible without moving your feet. Since this is very difficult, invite three students to join you in the square. Bounce the ball again, but this time, allow the others to help keep the ball in play. They cannot move their feet either. The ball must stay within the boundaries. How long can the team keep the ball going?

Guided Practice
Divide the class into groups of four and give each group a rubber ball. Draw enough squares for all groups. Have each group stand in a square. Remind them they may not move their feet and that the ball must stay inside the boundaries. Encourage students to work as a team to keep the ball in play.

Closure
Have groups sit down inside their squares. Prompt them to discuss how working as a team helped make the task easier. Encourage team members to thank one another for a job well done.

References

Gurian, M., & Henley, P. (2001). *Boys and girls learn differently!* San Francisco, CA: Jossey-Bass.

Kagan, S. (1994). *Cooperative Learning.* San Clemente, CA: Kagan Publishing.

Kagan, S. (2000). *Silly sports and goofy games.* San Clemente, CA: Kagan Publishing.

A Lifetime of Color™ (n.d.). *A landscape in warm, cool, and neutral colors.* Retrieved June 13, 2006, from http://www.sanford-artedventures.com.

A Lifetime of Color™ (n.d.) *Moody color.* Retrieved June 14, 2006, from http://www.sanford-artedventures.com.

Maquire, E. A., Frith, C. D., & Morris, R. G. M. (1999). The functional neuroanatomy of comprehension and memory: The importance of prior knowledge. *Brain,* 122, 1,839–1,850.

Messier, M. (n.d.). *Tasty color mixing.* Retrieved June 14, 2006, from the Kinder art™ Web site: www.kinderart.com/across/tasty.shtml.

National Council for the Social Studies. (2002). *Expectations of excellence: Curriculum standards for social studies.* Silver Spring, MD: National Council for the Social Studies (NCSS).

National Council of Teachers of English and International Reading Association. (1996). *Standards for the English language arts.* Urbana, IL: National Council of Teachers of English (NCTE).

National Council of Teachers of Mathematics. (2005). *Principles and standards for school mathematics.* Reston, VA: National Council of Teachers of Mathematics (NCTM).

National Research Council. (2005). *National science education standards.* Washington, DC: National Academy Press.

Sousa, D. A. (2006). *How the brain learns,* 3rd Edition. Thousand Oaks, CA: Corwin Press.